Annastasia's HAIR

AuthorHouse™ UK
1663 Liberty Drive
Bloomington, IN 47403 USA
www.authorhouse.co.uk
Phone: 0800 047 8203 (Domestic TFN)
+44 1908 723714 (International)

This book is printed on acid-free paper.

ISBN: 978-1-7283-9433-6 (sc)
ISBN: 978-1-7283-9432-9 (e)

Print information available on the last page.

Published by AuthorHouse 10/10/2019

authorHOUSE®

Annastasia's HAIR

NICOLA BRAMMER

There was a little girl called Annastasia. In most ways she was an ordinary creature, however she had one extraordinary feature; her hair. It wasn't extraordinarily long or extraordinarily short; it was the equivalent of a lion's mane – thick and fuzzy. It was so extraordinarily thick and fuzzy that it made the rest of her look – well – look rather – tiny.

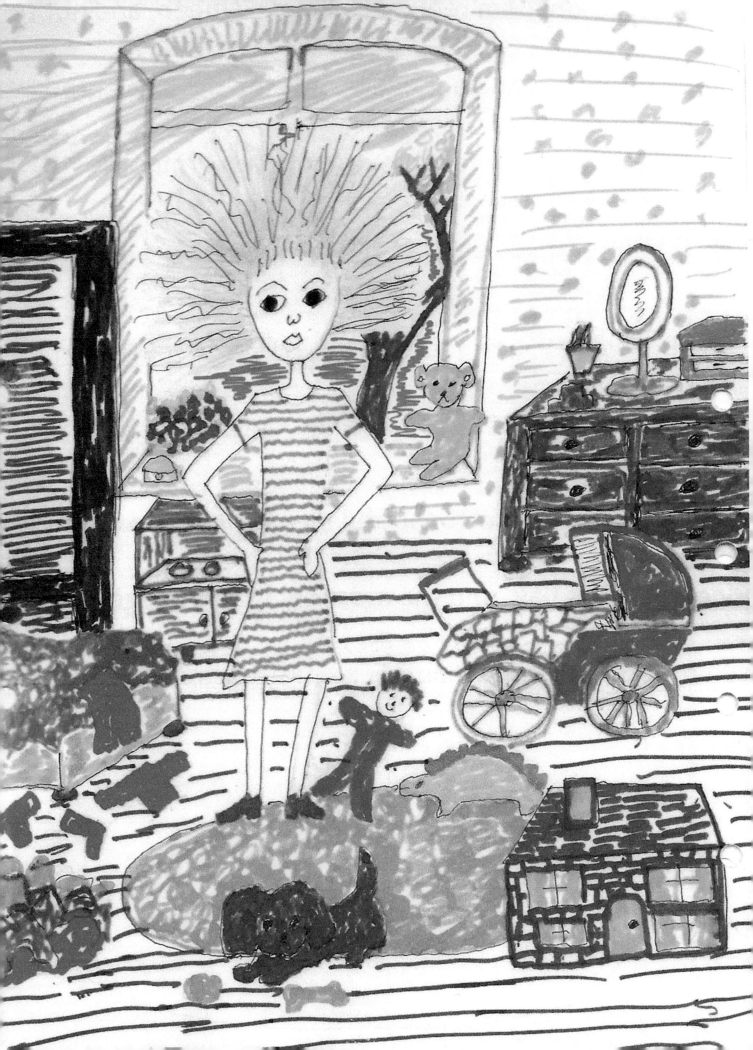

Of course, a kingdom requires a King, a Queen, and not to forget a prince, who happened to be the most talented Prince Tong, brother to the extraordinary Princess Annastasia.

Prince Tong had a very important part to play because of his numerous talents.

Queen Ong possessed beautiful big blue eyes, exquisitely long tresses of hair, and the most amazing of fingers which could turn Annastasia's unruly hair into beautiful, delightful designs.

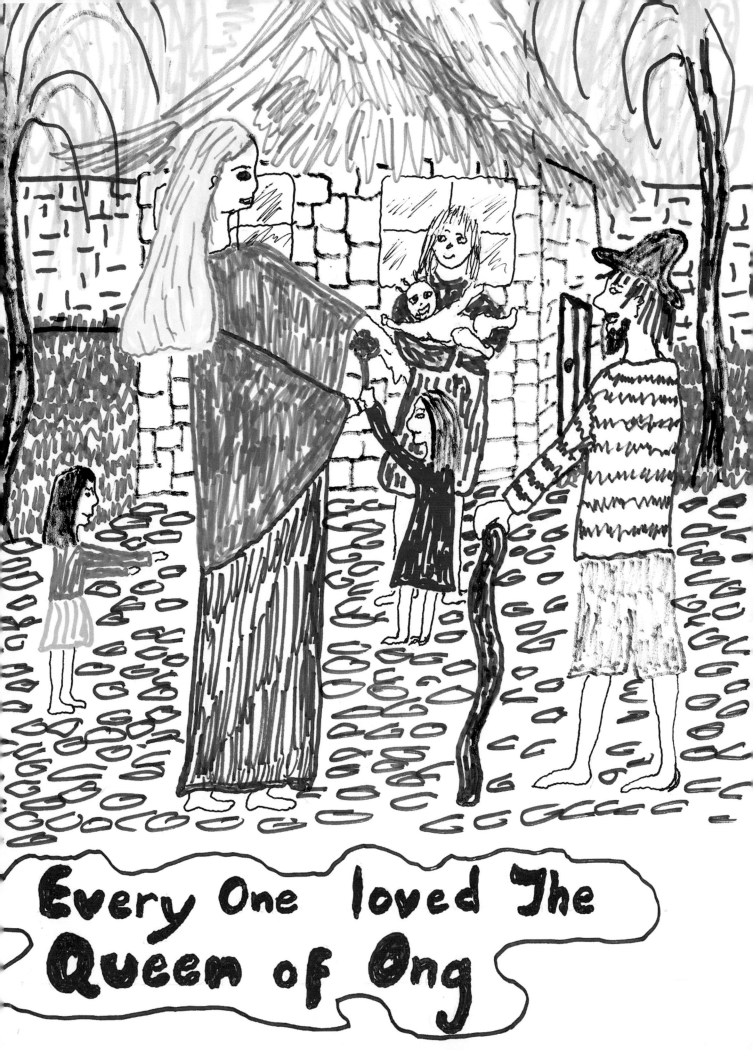

Every One loved The Queen of Ong

King Ong kept a wise eye on everything and everyone, while depending on his diet of amazing crepes which kept him happily agreeable, despite the conundrums of his extraordinary family.

There was another interesting quality of all subjects of the kingdom of Ong; everyone had straight brown hair, which could not be coaxed into any pleasing design except – straight.

This made Annastasia unique and infuriated the local population and causing them to envy her thick fuzzy mane; they would have given anything for a share of her fuzzy fortunes.

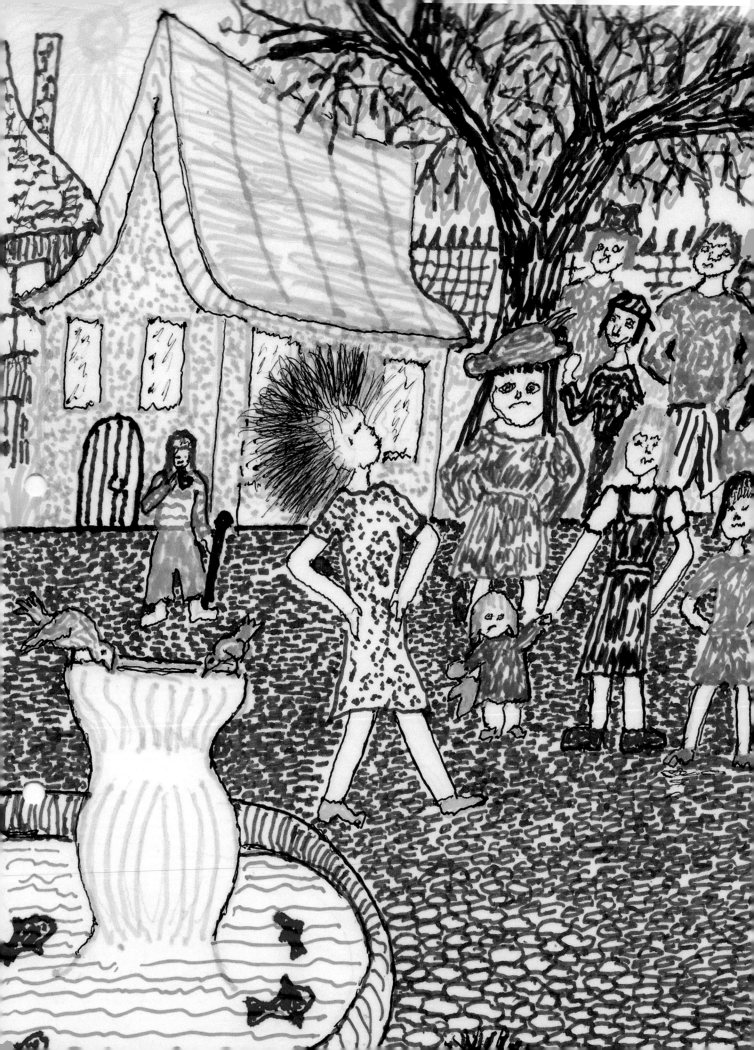

However, the secrets of her hairobic fortunes were only known by one person and guarded by Granny and her golden sword. Granny quickly tackled the advances of any mildly suspicious looking character, even the poor postman nervously approached the castle every day breaking out in a profuse sweat at any hint of the foreboding Granny plus sword.

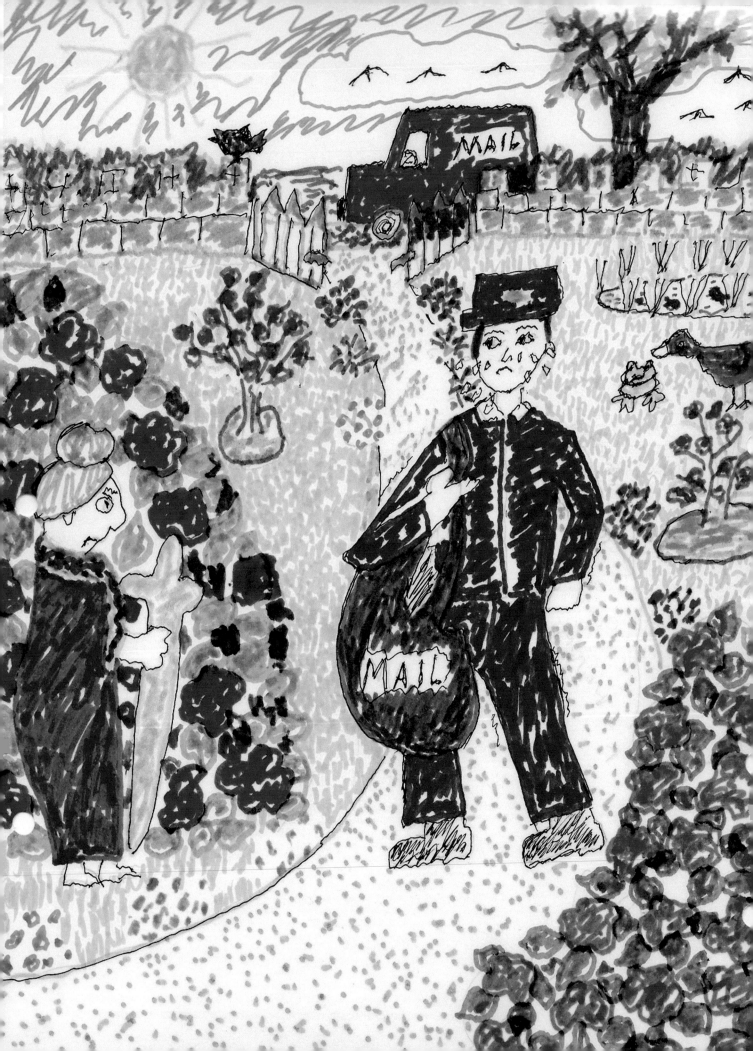

The Queen started her day with Annastasia's hair. Her head of hair was a great challenge even to such a patient Queen. She washed it once a week with a formula of the flowers of the valley. The lilies were made into a thick creamy conditioner, to give the poor Queen half a chance to unknot the hair.

She tenderly brushed it till it was rid of every knot and tangle, she combed it with a fine comb made from a rock only found in the kingdom of Ong, exquisitely rare, called the rock of many secrets.

The Queen was equipped with the most extraordinary fingers. Long and extremely slender, she tenderly sculptured Annastasia's tresses into any shape she desired.

They had tried all the top hairdressers in the land, however whenever anyone apart from Queen Ong touched Annastasia's tresses, her hair turned limp and refused to respond.

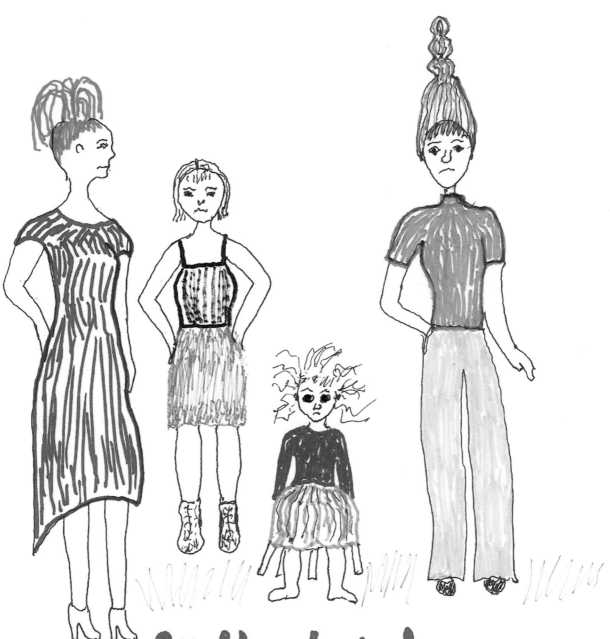

All the hairdressers
in the land could not
tame Annastasia's hair

Only Queen Ong was the right person to take care of Annastasia's hair, and it would never do for anyone else in the kingdom of Ong to become a rival of Annastasia's exquisite hair.

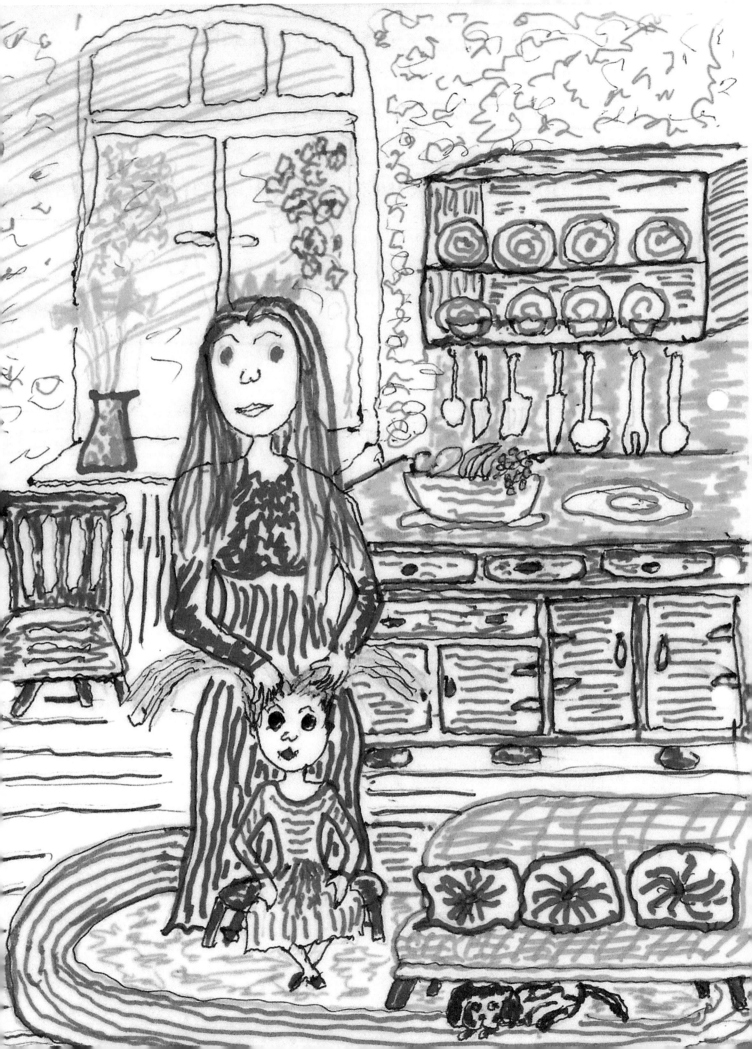

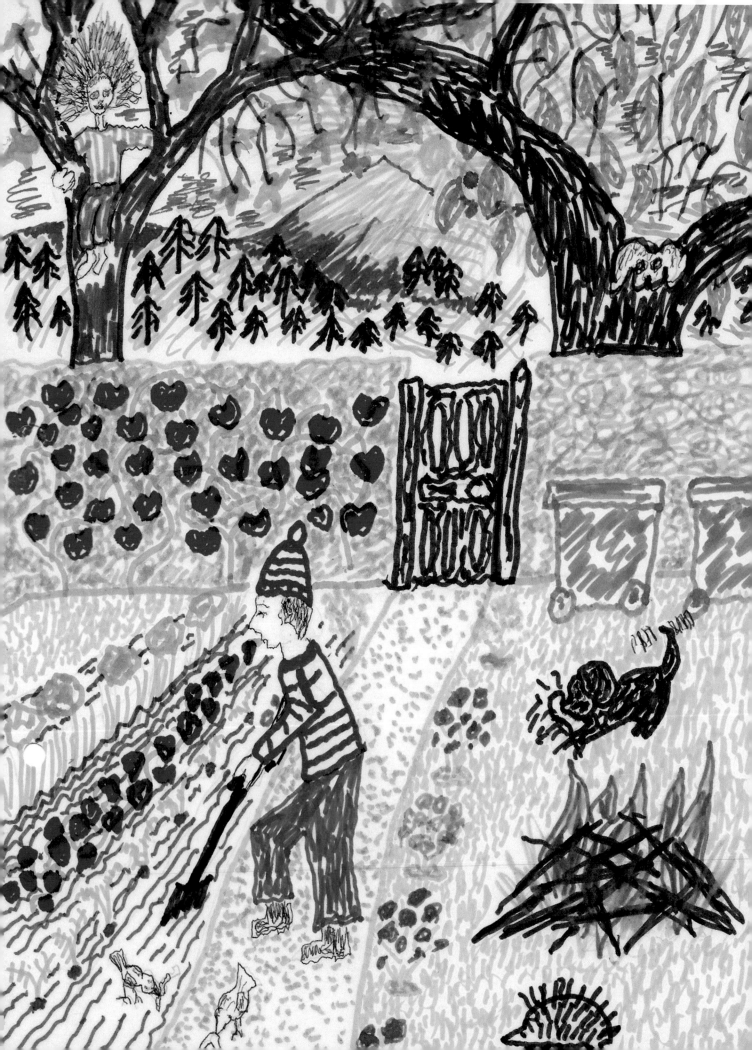

However, we mustn't forget Prince Tong, he had a great part to play in the care of his sister's hair. Prince Tong also had the most talented fingers which secretly took care of all the special things his sister had to eat to keep her hair beautiful.

Prince Tong would disappear to the mountains with his faithful dog Coco 1. Coco sniffed out all the herbs and truffles which were part of his sister's secret diet. He also had a vegetable patch which grew the most delicious vegetables. He kept animals, goats and hens. Whilst mentioning Tong's garden it's also worth mentioning Granny's part in growing delectable vegetables.

Sometimes Granny managed to scare someone a little too much with her golden sword.

Then the King and Queen took matters into their own hands. Amidst loud protestations from Granny, they would confiscate the sword and lock it away in the royal chamber.

This action always produced the same result in Granny.

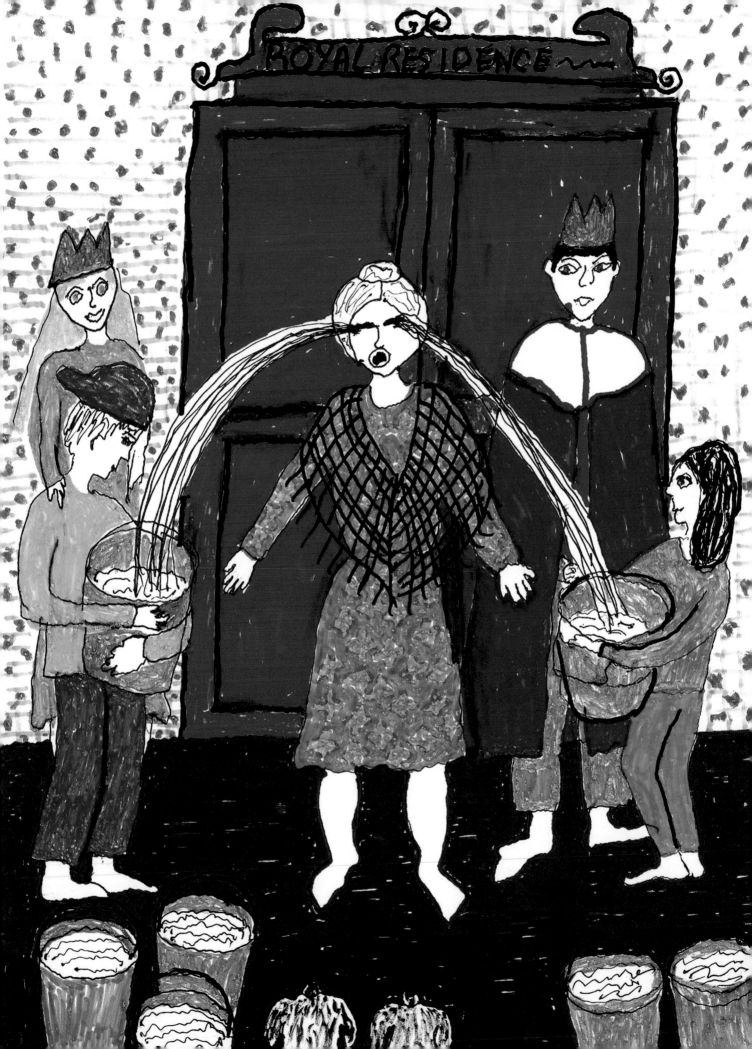

She would cry. She would cry so hard that the tears spurted from her eyes like water from a hosepipe.

Tong was always at hand with buckets. Seven buckets full, not a drop more or a drop less. Tong would then take the buckets and water all his vegetables.

Granny's tears must have contained some special ingredient, as the next day his plants would have grown and blossomed.

Even Granny had a part to play in the care of Annastasia's hair.

As for the chickens Tong raised, we will find out more in another story.

About the Author

Nicola Brammer. As a child loved to read and re-read her favorite books. She lost herself in the illustrations as her imagination carried her to unknown worlds. Due to ill health she lagged behind in education. She and her husband raised six children in tough times. But at the age of fifty a dream came true, and she completed a degree in English Language. She went on to tutor speakers of other languages. She and her husband moved to Glasgow from London. Her husband being Glaswegian. Sadly he passed away in 2017. It was after this event Nicolas's imagination awoke and a torrent of stories. She has been writing and illustrating her stories ever since.